D1237475

TOUCHING QUIET

Also by Mindy Weisel

The Rainbow Diet

The Beginning of Things by Harry Rand,
 Illustrated by Mindy Weisel

Mindy Weisel

TOUCHING QUIET
REFLECTIONS IN SOLITUDE

CAPITAL BOOKS, INC., STERLING, VIRGINIA

Capital Books, Inc.
P.O. Box 605
Herndon, Virginia 20172-0605

ISBN 1-892123-31-2 (alk.paper)

Library of Congress Cataloging-in-Publication Data

Weisel, Mindy
 Touching quiet: reflections in solitude / by Mindy Weisel.
 p. cm.
 ISBN 1-892123-31-2
 1. Weisel, Mindy--Diaries. 2. Painters--United States--Diaries. 3. Weisel,
Mindy--Themes, motives. 4. Solitude in art. I. Title.

 ND237.W414 A2 2000
 759.13--dc21 00-059892

Printed in Mexico on acid-free paper that meets the American National Standards Institute Z39-48 Standard.

First Edition

10 9 8 7 6 5 4 3 2 1

On the cover: *Of Country Fields and Torn Skies*, watercolor and oil pastel, 60" x 40", 1992, by Mindy Weisel.

FOR SHEL

CONTENTS

ACKNOWLEDGMENTS

My heartfelt and deepest thanks:

To the fine people at the Virginia Center for Creative Arts, for creating a quiet haven in which artists are free to make their work.

To Kathleen Hughes, the publisher of Capital Books, whose wisdom, kindness, and generosity I will always hold dear.

To my art dealers at the time of the *Touching Quiet* exhibit: Sally Troyer, Sandy Fitzpatrick, and Vivienne Lassman—I give deepest thanks for your friendship and your efforts on my behalf.

To Diana My Tran, who shares my art life with great generosity.

To Alan Hughes, for his excellent work in transcribing pages and pages of notes.

To Terri Oakley, for her invaluable assistance, kindness, and loyalty.

To Anne Abramson, who gave me the beautiful journal to take with me on my fellowship, and to Lois Adelson, for encouraging me to use it.

To Hadassah Lieberman, a true soulmate, for helping me hold onto the quiet.

To my family and friends, blessedly too numerous to list individually, but as the saying goes: "You all know who you are." I thank you for your love and encouragement.

To my brother Jack, for understanding how hard earned quiet is.

To my father, Amram Deutsch, and his wife, Dita Sidlow Deutsch, I give thanks for your constant enthusiasm.

To my daughters, Carolyn, Jessica, and Ariane, and to my son-in-law, Daniel: you are my joy.

To my husband, Shel, I give deepest thanks and love for creating a meaningful life, and encouraging me to live it.

To my mother, Lili Deutsch, in blessed memory, thank you for teaching me to listen to my heart.

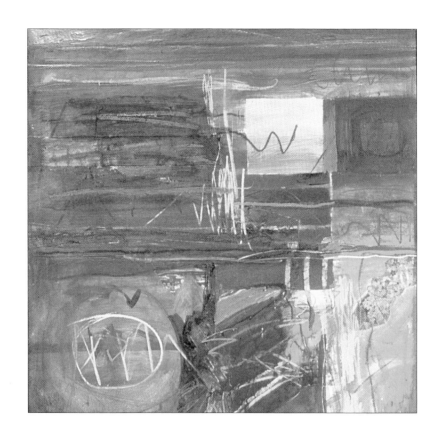

Looking for Quiet,
38" x 37½", watercolor
collage, 1992.

PREFACE

In spring, my mother made Hungarian cherry soup. She served it in crystal bowls, as they did in Hungary, where she was born and raised. My father, a deeply spiritual man, would start his sixteen-hour workday quietly saying his daily prayers, allowing himself a small measure of peace and quiet. These seem like small gestures, but to me they spoke volumes. They were examples that these two survivors of Auschwitz, of Nazi Germany, still valued beauty and solitude. These values not only served me well; I made them my life's work.

Touching Quiet is a record of a most unusual time in my life. In 1992 I was given a one-month painting fellowship at the Virginia Center for Creative Arts. I had dreamed for years of having my three daughters independent enough that I might paint without worrying about the other daily demands of my

life. I have been a painter for twenty-five years, never having more than three or four hours a day to work, because this painting time was always wrapped around a myriad of responsibilities: being the wife of a hard-working Washington attorney and being a mother to my daughters, Carolyn, Jessica, and Ariane—each born five years apart.

This fellowship enabled me to paint for one month without any of life's normal stresses or distractions. Three meals were prepared daily, and lunch was left at the studio door at noon. My time, my schedule, my life were my own. One woman writer there at the time told me she does these fellowships as an opportunity to catch up with necessary sleep.

I did not just sleep. I painted my heart out. This journal became a record of what it feels like to live with quiet

> Quiet became the subject of each day's work. . . .This quiet was not always exquisite. At times it was excruciating I was unbearably anxious, not knowing where to "run."

and solitude and beauty. Quiet became the subject of each day's work. My desire was to learn what quiet really felt like and to put those feelings into the painting. This quiet was not always exquisite. At times it was excruciating, as in the days I worked on the painting *A Storm of Solitude*. I was unbearably anxious, not knowing where to "run." I was in a situation where I had to live with myself only, and the sole demand I placed on myself was to experience the quiet fully—and to learn from it. I also learned to respect, admire, and value quiet time and to fully understand how necessary it is in the context of my very busy, demanding life. It is my hope that it is something, if not already there, that you will allow into your own lives.

It is not necessary to "remove" oneself, as I did when I kept my journal in 1992, to experience, appreciate, respect, and permit moments or periods of quiet. In fact, in March 2000 I am working on this book in one of the busiest, most intense

cultural and religious centers of the world: Jerusalem, Israel. I brought myself here for one month while my youngest daughter, Ariane, is here for a year, studying. The small, light-filled apartment I am renting is directly across from the Old City, where people from all over the world congregate. I do not allow myself to be seduced by what I know is "out there" until I have first had my few hours of quiet reading and writing time. I stay focused in my desire not only to complete this book but also to experience quiet in the midst of tremendous activity around me.

The idea of this book is that no matter where we are, or what we are doing, we find the few quiet moments we can in which we are *with* ourselves. We retreat into ourselves, not as an escape or avoidance of life but rather as an opportunity for contemplation, reflection that actually allows us to be more productive and focused than we are when we are constantly "on the run."

INTRODUCTION

My appreciation for quiet has been hard earned. My parents worked long hours in their bakery business, six days a week. Their idea of enjoyment was retreating to their room at night with a bowl of fresh fruit, some quiet conversation, a bit of TV. Then it was up at 3 A.M. again for my father, going to his bakery business, with my mother soon following.

They were always in a hurry. I learned to do things very fast, very efficiently, and with the same lack of patience they exhibited. I expected each day to be productive with no time to waste. What I have learned is that being quiet is not a matter of wasting time. It is, however, something harder and harder to come by. We live in a constant state of noise between the cellular phone, the computer, the fax machine, the telephone, the microwave, the television, the radio, the treadmill, the answering

machine, the dishwasher, the dryer—there is something ON all the time. There is no question that all these technological advances have made our lives easier physically, but I am very aware of the damage done to our nerves. There is so much noise and busy-ness in our lives that we don't have time or space for reflection or contemplation.

There are very few places where we can go anymore to have quiet. I used to love to take the train from Washington, D.C., to New York. During the three-hour ride, I would try to catch up on some reading and take a short nap. It was a chance to be with my own thoughts and feelings for a while. Not so anymore. Everyone has a cell phone attached to their ear, and even as I try to get away from my own, I become privy to the stresses and demands of the lives of complete strangers.

It is to our benefit to hold on to a measure of quiet in our daily lives as much as possible and to respect the value of it.

On a recent trip to Cairo, Egypt, I met several fascinating, busy women who reflected a very strong, yet quiet, sense of self. One lovely French woman in her early forties told me she is actively "simplifying" her life. She accepts fewer and fewer social obligations, choosing to spend more time reading or resting. Another woman expressed a desire to spend more time with herself and her garden, while the businesswoman in the group, who runs a successful art gallery, told us all that the secret lies in learning to balance appointments. She does not let herself overload her day and makes sure to schedule an appointment with herself. It was inspiring and refreshing to be with women who, whether they worked or not, were so acutely conscious of the importance of safeguarding time for themselves.

I've always felt guilty acknowledging that I was taking time for myself. When I do, I find myself rationalizing that I "deserve" this time because I've been "working very hard" or

I "need a break." Why do I need all these excuses? When did it become wrong or "selfish" to take good care of oneself?

I am not suggesting in this book that we all become self-absorbed hermits or hedonists. It is clear, however, that we have gotten so far from being with ourselves that we have lost our focus on what is important in our lives. As a result, any creative energy we might have becomes dissipated.

The more we run and the farther we get from the center of ourselves, the higher our level of anxiety becomes. It takes time to be with ourselves, to know who we are, to understand what we feel and what we care about. What we must give our energies and time to and what we can let go of. Quiet is the soil, the foundation, the air, the light that lets ideas flow and allows peace and harmony to enter.

The more we run and the farther we get from the center of ourselves, the higher our level of anxiety becomes. It takes time to be with ourselves, to know who we are, to understand what we feel and what we care about. What we must give our energies and time to and what we can let go of. Quiet is the soil, the foundation, the air, the light that lets ideas flow and allows peace and harmony to enter.

Having quiet in our lives requires some preparation. Before I started my fellowship I prepared myself as someone might before a marathon. I spent a great deal of time thinking about everything from what books I have always wanted to read and what kind of music I have longed to hear to which of my husband's old shirts that I like to paint in I should take; what art supplies I would need to work with for a month; what responsibilities needed to get done before I left—what needed to be cooked and prepared; what bills, calls, letters, and household chores needed to be attended to; what my daughters would need for their summer month away; on and on. And it is not very different now, eight years

> *Quiet has become a part of my daily list making to find where and when I will have time for myself. My friends joke that I am the only person who has made "rest" an "activity". . . Incorporating quiet as a serious part of my day has not only enhanced my creativity but calmed my nerves as well.*

later. It is very much a part of my daily list making to find where and when I will have time for myself. My friends joke that I am the only person who has made "rest" an "activity." It gets written down on my list daily and gets crossed off, at the end of the day, with the same sense of accomplishment

I feel about whatever else must get done.

I am someone who has always been in a hurry. Tormented by such questions as: Am I in the right place? Should I be here rather than there? Am I doing enough? Will I get it all done? And ending the day exhausted. For me to spend an entire month in and with quiet was a rarity. Now, however, quiet is an essential part of my day. I find I am not nearly as anxious

or as exhausted as I used to be. Incorporating quiet as a serious part of my day has not only enhanced my creativity but calmed my nerves as well.

Only we can create quiet for ourselves. Only we know what will enhance the quality of our lives and diminish, somewhat, its demands and stresses. Do we need more time to read? To exercise? To pray? To write? To paint? To dance? To cook? To garden? To meditate? Or to just be?

It is my hope that the following journal will serve as an inspiration for anyone seeking a greater measure of balance, harmony, and creativity in their lives. Enjoy.

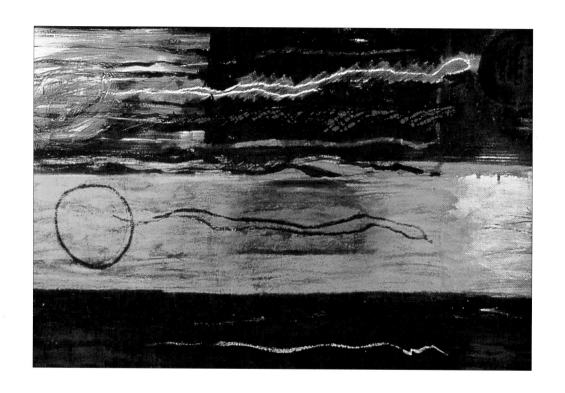

Of Snakes and Partings,
watercolor, acrylic,
pastel 40" x 60", 1992.

Following page:
detail from *Of Snakes
and Partings*.

JOURNAL

MONDAY, JULY 6 Shelly drove me here, to the Virginia Center for
Creative Arts, today. It is set in six hundred acres of country quiet.
Took us three hours to get here from Washington, D.C. He was
beyond helpful and supportive—helped bring in all my stuff
from my studio at home: paints, brushes, canvas, paper, music,
clothes—and set me up, making sure I had fresh bottled water
and all I needed to settle in. I'm glad we agreed to meet on
the weekends—makes me feel less anxious about us being
apart for a month.

The studio is a large converted barn, high ceilings, great light,
lots of walls to put work up on. And it has a small bed to rest.
I had a difficult time parting from Shelly. I started to cry as he
was leaving. I felt overwhelmed with feelings of gratitude for
his understanding and support of my life as a painter. It can't

> I wonder at my sanity in wanting to be here, away from the familiarity of my home and studio—and putting myself in this much-too-quiet place. What was I thinking?

be easy being married to a painter! But then . . . it's not easy being married to a lawyer.

Shelly and I were awed by the quiet here, the acres and acres of green quiet. When we first got here, as I was walking to my appointed studio, the first thing I noticed was a blacksnake—it not only scared me, I worried it was a bad omen. They tell me there are a lot of them around and they are not harmful. I wonder at my sanity in wanting to be here, away from the familiarity of my home and studio—and putting myself in this much-too-quiet place. What was I thinking? I already miss Shelly. As soon as he leaves I unpack, get my room all in order—I love the simplicity of it. I go over to the studio (it is huge and light-filled) as soon as I put on an old white shirt and my painting jeans and my music (Richard Stoltzman's *Brazil*—great tape!). I can once again be alone—

with myself. My work. But now I can do it without interruption or rush. Or worry about what else is not getting done. This sense of freedom feels exhilarating and strange.

I notice that I never feel alone when I have my brushes, colors, papers, walls, tables, books, and music around me, the tools that allow my inner life to be expressed, and for now I long to be nowhere else.

So—for the first time ever my life is designed—for four weeks—solely to paint. Right now I do not need to be a mother, wife, daughter, sister, friend—all that is expected of me is that I do my work. Or not. I can read, walk, sleep, just *be*. I am in a dream for sure. And all this quiet and knowing that other artists are working nearby, in their own worlds and spaces. I cannot believe nothing else is expected of me. Can I just be a painter? How will I do in all this quiet?

I wonder what the others here are like. VCCA has up to twenty-three artists working here at a time. Each is given a room in the residence building and a separate studio in the large converted barns. There are writers, poets, composers, painters, and sculptors here.

TUESDAY, JULY 7 / 7:50 A.M.

I slept really well last night—felt safe and "finally here." Got up at 6:45 A.M.—bathed quietly in my bathroom (I've not yet met the person next door who shares this bathroom) and went down to breakfast: fresh biscuits, eggs, cereal. At the table: Ann, a fiber artist; Simone, a writer; and Janice, a writer. Interesting and warm and friendly. It is a gorgeous, clear, sunny day. I just walked into my studio into the most gorgeous morning light I have ever seen. Unbelievable that the day and night will be mine for a month. I'm all settled and have everything I need in my simple little bedroom and my

spacious studio. Interesting, how happy I am with so little—not burdened by things that need my care and attention. I am thrilled by what I don't have. No phone. No TV. No car. Not much furniture. No objects. Just light and peace and quiet and fields and fields of summer.

I am thrilled by what I don't have. No phone. No TV. No car. Not much furniture. No objects. Just light and peace and quiet and fields and fields of summer.

1 P.M.

Worked on *Of Snakes and Partings* this morning. Just ate my lunch (left in a lunch box at my studio door), joining five women writers who were having their lunch outside in front of the barn. Just so serene here. I started drawing the snake I saw when I first got here—and trying to express how hard it was for me to separate from Shelly by using shapes that separate one from another. Napped from 1:15 to 3 P.M. Back in studio, refreshed, at 3:15 and worked till 4:30. At dinner

everyone introducing themselves to each other. Delicious home-cooked food. Walked quietly by myself for an hour after dinner.

STUDIO, 8 P.M.

Finished *Of Snakes and Partings*—the blues are references to the trip to Israel and the Mediterranean that I took before I arrived here; the black is the snake at VCCA; the rest of the painting expresses my parting with Shel on Monday. I never know what I am going to paint. I tell myself not to think, just to paint what I'm feeling. Interesting experience working at night.

I never get to work in the evening at home. I'm not only too tired at home; it's usually also "family time." I always thought I could work only in the morning, but there is enough energy here for me to last into the night.

When I paint I make my marks randomly and start to write what I'm feeling on the paper or canvas. I'm never sure where the painting is going. I paint layer upon layer, feeling upon feeling; the work takes on a life of its own. It's the process I love.

WEDNESDAY, JULY 8 / STUDIO, 8:30 A.M.

Woke up at 5 A.M. Dozed in bed till 6:30. At breakfast by 7:00. Wonderful people here—composers, writers, filmmakers, painters—everyone warm and serious and speaking "my language." I sketch a gnarled tree outside, in a field, for half an hour; am in the studio again and prepare my canvases for painting; then fall into a deep sleep from 9:00 to 9:45. I call Shel, check the mailroom and am thrilled to see a letter from Ariane in my box; it's already 10:15 A.M. and I feel very, very tired—or wound down—or maybe all the adrenaline required for my getting here is draining away today—I cannot believe this quiet, this beauty, this absolute joy in being with myself, my work, life with no distractions.

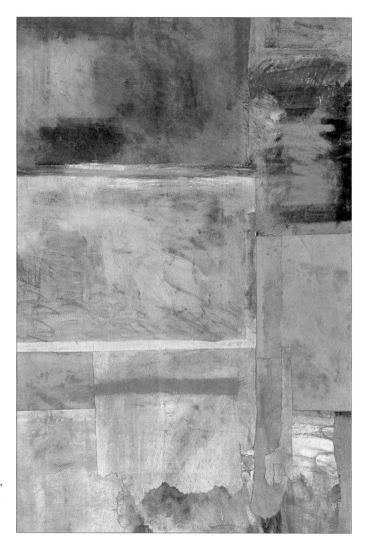

Touching Quiet,
collage: watercolor,
oriental handmade
paper, oil pastel,
34" x 26", 1992.

At first I feel anxious being in this very quiet, serene place.
Not used to the silence—no urban sounds and no place to
run. What on earth will I paint here for a whole month? I
think I'll make quiet the subject of each day's work. What I
see, think, and feel in response to this quiet. I'm ready to start
work this morning, finally (10:30 A.M.—late!) and will try to
start a painting I'd like to call *Touching Quiet*.

STUDIO, 2:15 P.M.

I couldn't really start to paint till around 11:15—and I felt
very anxious about getting this *Touching Quiet* out—tried
different papers and different paints—frustrated, I finally took
a break and then did a watercolor on rice paper—I loved the
softness, the way the sheer paper absorbed the paint and left
the feeling of quiet—I sat on the floor for three hours and
did six washes on rice paper, then collaged them onto
stronger watercolor paper—I feel happily spent—I just fin-
ished. The piece really reflects the soft heat of summer and

Facing page: detail from
Touching Quiet.

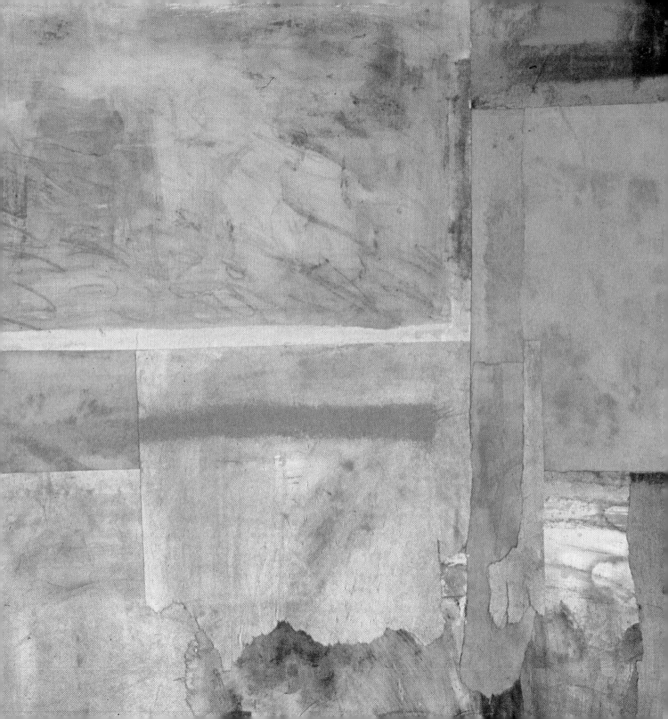

the quiet air around me. Will read for a while now, then go do my two-mile walk.

THURSDAY, JULY 9 / 7:45 A.M.

I don't know if it's the country fresh air or if I am finally totally relaxed—I sleep so much here! And I sleep well. Slept yesterday afternoon for an hour during the day and still was able to sleep from 10 P.M. to 7 A.M. I'm in the studio early because I heard it's going to be 95 degrees today. The people here are becoming more familiar, and I'm not feeling as homesick as I did the first few days. (Simone, the writer, gave a reading of her work last night.) I'm going to work on a painting called *Torn Skies*. On my walk after dinner last night, I noticed that the mountains seemed to touch the sky and their outline looked torn, the way I tear paper to do a collage. Also, the title is a good

Incredible this staying here all day—running nowhere. Time to reflect-look-rest-work.

metaphor for my life in general. I start each morning here
with Richard Stoltzman's music—a gentle clarinet tape called
Inner Voices—and I study paintings by Manet. He is clearly
one of my favorite painters. His brilliant brushwork, color,
composition, and use of black are just plain exciting. One of
my favorites is *Lady with Fans—Portrait of Nixa de Callías*.
His use of black is as a rich color and not a void. It is elegant
and mysterious.

10:30 A.M.

The painting *Torn Skies* became Of *Country Fields and Torn Skies*.
I really had to push through myself to paint it "freely," with-
out thinking. Just feeling. I tell myself to not think as I work.
It will not help me to think. Just feel what I need to feel and
use the materials to express that. Finished it at 4 P.M.
Incredible this staying here all day—running nowhere. Time
to reflect-look-rest-work. Did a little watercolor called
Old Doors while waiting for *Torn Skies* to dry. My mind feels

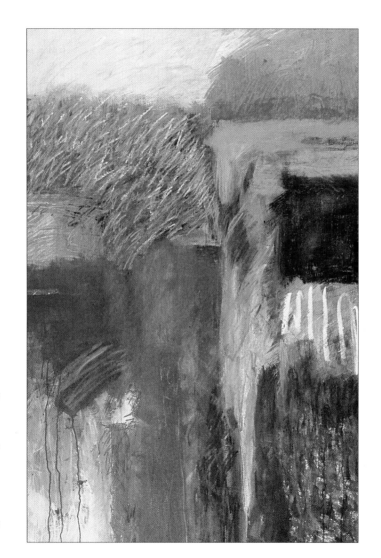

*Of Country Fields
and Torn Skies*,
watercolor, oil
pastel, 60" x 40",
1992.

Following page:
detail from
*Of Country Fields
and Torn Skies*.

clear and full at the same time. I move naturally from work to work, or work to rest, or work to reading, or work to meals, or work to sleep . . . I feel in a natural, centered rhythm and don't feel pushed in a million directions at once, as I usually do at home.

FRIDAY, JULY 10

Went to the movies last night with some other fellows— nothing special but fun to be "out" . . . this morning up at 6 A.M. Two-mile walk from 6:30 to 7:00. Enjoying the cool morning calm. At breakfast talked a lot with Ann (the weaver), and she came into my studio and I went into hers. People come in only when invited—there is a great respect for another's time. I love it here. I'm going to work on a piece today called *Absorbing Quiet* (one writer here tells me this morning that there are women like me who are "high absorbers"—meaning taking *everything* in, highly intuitive, etc., and feeling everything).

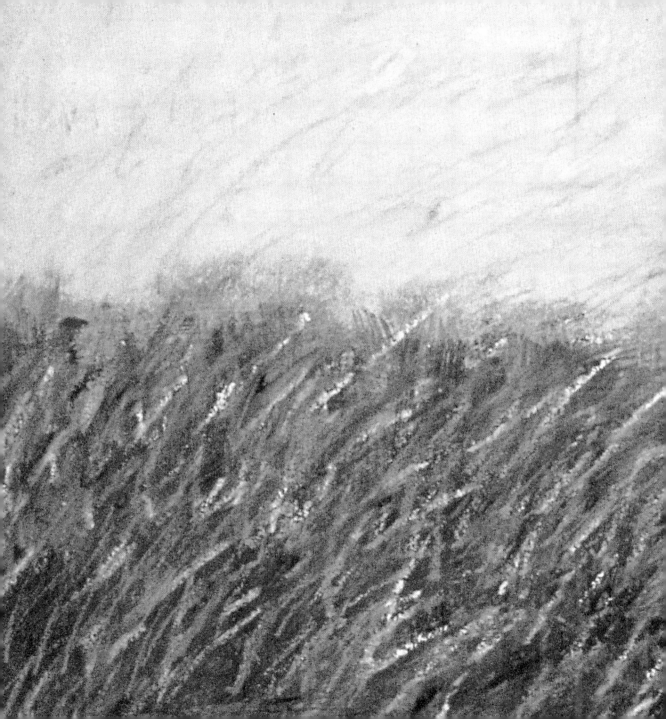

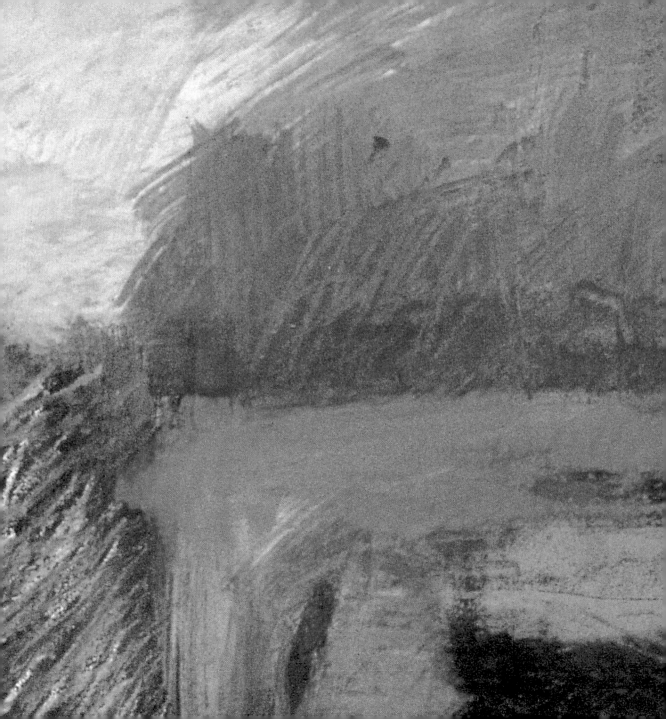

Ann tells me the snake is a symbol of female intuition (not a bad omen after all). Ann has lived in Yugoslavia, India, Poland, Peru, etc. Very lovely, honest, bright woman. She told me when she first met me she could tell I was anxious and intense because when we talked in a group I moved from subject to subject too quickly—not letting myself focus—and since then I've clearly gotten more relaxed and now can stay with one topic of conversation. Today I decided to call the series I'm working on while I'm here *Touching Quiet*. It is what most fascinates me here—the quiet

11:45 A.M.

Worked for two hours—I think this painting on paper will be called *Fields Not in My Imagination*. I sit in front of it a long time to see if anything moves me to change it—I feel no need to change it, because I really like the energy and activity and the color of it—the deep greens of it. I think I'll leave it. Dare I, after just two hours of work? Some of my best work

actually has come out of a quick burst that comes after days of doing other work. I will sit in this almost unbearably hot studio until it is time for me to bathe and go to the airport—will look at some Manet, whose work never fails to surprise and delight me. (I need to go home this weekend so I can attend Ariane's parents' visiting day at camp on Sunday.)

Monday, July 13

Spent the weekend with Shelly at home. He picked me up at the airport, and we picked up some delicious salmon to have for dinner. It was just us till Sunday—very romantic—very loving—we went into the swimming pool with only the moon giving us light.

Sunday I was so excited to go visit Ariane at camp! She is turning into a lovely young girl—she is so wonderful I wanted to put her in my pocket and bring her back with me.

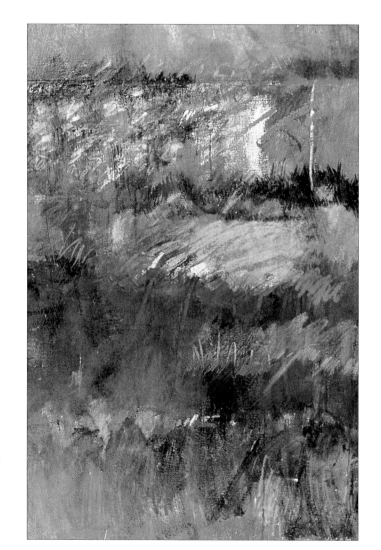

The Fields,
watercolor, oil
pastel, 50" x 30",
1992.

Following page:
detail from
The Fields.

She seems happy at camp. All her friends are there. Carolyn, whom I saw very briefly this weekend seems to be doing very well, and Jessica called from her Summer Across the United States trip—I told her she'd better come home healthy or no changing schools in the fall. My daughters . . . may they always be protected.

Shelly drove four hours to get me back here to VCCA last night (so good to see the fellows again) and then drove himself right back for another three hours to D.C. I loved it when he visited the studio to see what I'd done during the week. He seemed genuinely excited by the work I'm doing and seemed to be proud that I'm here.

It is so good to be back. Slept 10:30 P.M.–6:30 A.M.—talked to Ann next door—had breakfast and was in the studio at 7:30 this morning. Putting away some supplies I brought from home. Finished *Of Country Fields and Torn Skies* just now.

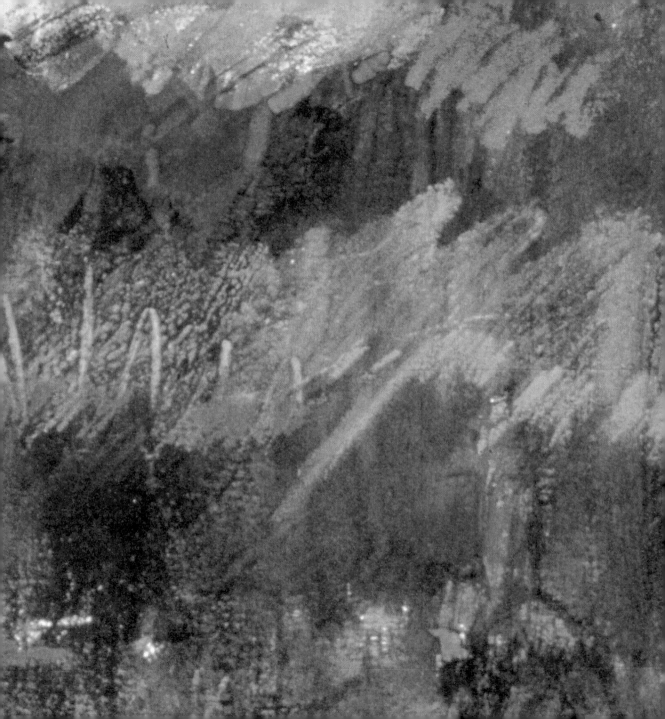

> How can I not see the lake while I'm here? I remind myself I have time to do all I need and want to do, and I should allow myself this pleasure.

Happier with it. It feels more constrained and peaceful and reflects more honestly how I am actually feeling.

Did a painting—mixed media—in eight squares, called *Thoughts in Solitude*, as I am reading Thomas Merton's book by that name. Lunch. Slept one hour. Went to the one pay phone here and talked to Shel. From 2:30 to 4:30 worked on a painting I first called *Anxiety in Green* while I was working, but now I'm changing the title. (I had a *terrible* anxiety attack in my studio this afternoon—felt trapped, alone; another three and a half weeks of this quiet—can I take it? Will I be able to keep working?) Terrible panic attack. Painted through it. Calling the painting *A Storm of Solitude* instead and will continue to work on it tomorrow. Hopefully feeling less anxious.

Saw slides last night by a sculptor from Minneapolis. I love

her work. It's inspiring; very strong yet elegant. Slept well.

Strange dream. Anyway, I feel less anxious today. Will work on

A Storm of Solitude this morning, and then I'm planning to go

to Sweet Briar Bookstore with Ann. The quiet and beauty felt

delicious this morning as I lay in bed. I opened the curtains,

and I got lost in reverie, looking at the shapes of cloud and

sky between the branches of trees.

I felt I could have stayed in bed

like that all morning. How strange

not to rush out of bed as I do at

home. For the first time ever I feel

like I have time. I do have time.

Taking the time to see, one of the

most important parts of being a

painter is what I have the least time

for at home.

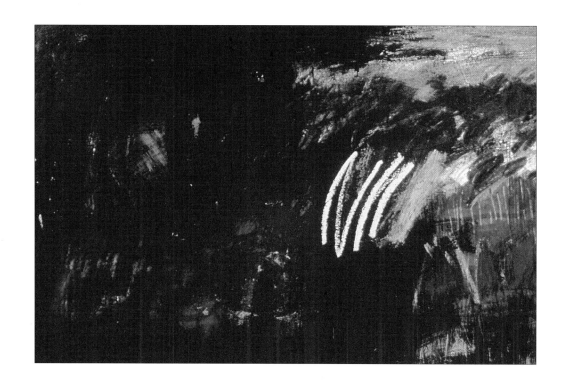

A Storm of Solitude,
watercolor, oil stick,
40" x 60", 1992.

Following page:
detail from
A Storm of Solitude.

11:30 A.M.

I'm so hot in my studio (it's been in the high nineties) I feel
like I'm going to pass out—I am totally drenched while I
work. I go to the office and ask for a fan, so they bring me
one that is so noisy—as I set it up, I realize I'm trading air for
quiet. Had a good morning working—finished *A Storm of
Solitude,* and I love it. Feel better. The flash of light coming
out of the darkness is exactly how I felt once I got through
the anxiety of being with so much silence. Some of the writers
stop in occasionally, see how I'm doing, and I knock at a
writer's door for some popcorn I smell down the hall. I'm
ready to work some more. Don't feel as lonely today. I was
invited to go to the lake this afternoon at 4 P.M. It's so hot
here, I know that should feel good, yet I feel guilty for leaving
the studio. But everyone talks about the lake and how cool
and beautiful it is in this intense heat. How can I not see the
lake while I'm here? I remind myself I have time to do all I
need and want to do, and I should allow myself this pleasure.

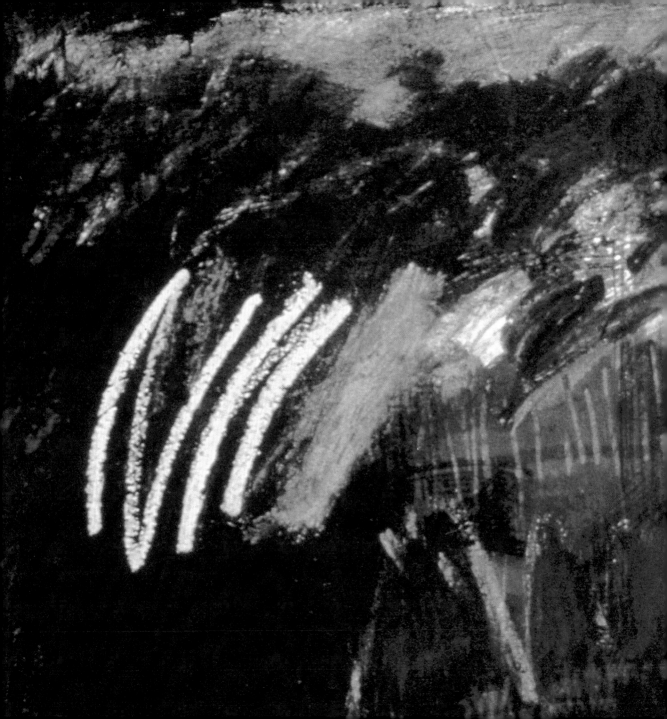

I can't believe how much I sleep here! Slept from 9:30 P.M. to 6:30 this morning. Feel refreshed after yesterday at the lake; I took the whole afternoon off. It is cooler today. I turned off the noisy fan, and Ann loaned me a good quiet fan. I'm going to start painting. I'd like to stay in here all day—I missed this studio yesterday—but it was like an oven, the heat was so intense. It's July in Virginia! I'm feeling less lonely, am finding my friends and the conversation interesting—yesterday went to Sweet Briar with Ann (bought Nabokov's *Lolita*) and met Marilyn, a writer from the University of Kentucky, at Samanda's, a 1960s-looking health food café, for lunch. She picked out a perfect cool cotton turquoise top for me. I bought ground barley to mix in a drink—keeps you healthy, they say. Tastes vile! Later.

54

> I notice I'm slowly changing from when I got here: at first all I felt I should be doing is work. Now I am allowing myself the much-longed-for dialogue with other creative people

It's 9:30 A.M. already—just getting to work—went back to the dining room to get a cup of coffee to wake me up, and Joelle (the composer) walked back here to the studio with me—came in to see my work, and I was curious to see her studio, which is in a charming separate building, with a piano in it and walls and walls of sheet music taped up—she's working on a piece called *Sweet Briar Elegies*—has her doctorate in music. Her husband had a heart attack at forty-seven and died four months ago. She has been here at VCCA nine times! I like her. She's very "New York" and refreshing in this country setting.

I notice I'm slowly changing from when I got here: at first all I felt I should be doing is work. Now I am allowing myself the much-longed-for dialogue with other creative people, and I'm allowing myself the time to talk with them. But now must get to work. Working on a piece called *The Lake*.

The Lake,
watercolor,
oil pastel,
34" x 42", 1992.

Following page:
detail from
The Lake.

12 NOON

Worked all morning on *The Lake* and finished it. I am happy with it. It is magic born out of a real struggle with my materials or a real using of all my materials—watercolor, oil pastels, chalks, watercolor pastels, etc. The piece feels like the cool, cool lake of the other day, filled with many, many shades of blues and greens.

THURSDAY, JULY 16 / 9:20 A.M.

Went to sleep at 8:45 last night and slept almost ten hours! I'm storing up all right. I think we are all much more sleep deprived in our daily lives than we realize. Wrote some cards to the kids and a letter to Miriam this morning—and finally finished *Fields Not in My Imagination*, which was just too colorful for my taste. I like it when a painting is actually full of color but you only let hints of it show through. It's the layer-

ing—the reality that something exists *behind* what you see that intrigues me. I'm going to work on a painting called *What Was*.

One of the writers stopped in this morning to see *The Lake*, and I enjoyed her response to my work. I feel like crying this morning. I am sometimes positively overwhelmed by the sadness that nothing—no moment—lasts. It's all over too fast—too soon. I can't bear that life *is* so fleeting. . . .

Did a black-and-white painting called *What Was*. I am reading Jung's *Man and His Symbols*—will read that in the studio and read Nabokov's *Lolita* in the room I sleep in. Have been revising *Fields Not in My Imagination*—it is now torn down to half its original size of 60"x 40" and am just calling it *The Fields*—feels more honest. Clearer. The amount of *color* in it feels right. There are something like eighteen shades of green in that painting.

PAINTINGS TO DATE:

Of Snakes and Partings

Touching Quiet

Of Country Fields and Torn Skies

Old Doors (gave to Ann Schumacher)

In the Face of Solitude (gave to Marilyn Kallet)

The Fields

Thoughts in Solitude

A Storm of Solitude

The Lake

What Was

SMALL WORKS:

Summer Storms

Hearing Quiet

The Dream (about Miriam buying bracelets in Israel)

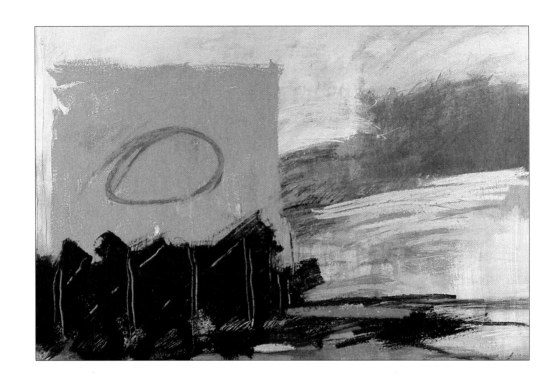

The Dream,
acrylic, oil pastel,
34" x 47", 1992.

Following page:
detail from
The Dream.

Went to Wintergreen, mountain retreat, with Shelly this week-
end—we had a great time together. I'm in the studio this
morning after eleven hours of sleep (8 P.M.–7 A.M.). I do get
exhausted by life and my own intense emotions. If I didn't
paint, I'd probably be dead by now. Where would I put all this
emotion?

Thank goodness Ann is here at VCCA during my stay. She has
a wisdom, sensitivity, and spirituality that is giving me much
insight and strength. She has a tremendous empathy and feels
it is time for me to let go of the pain and anxiety that eats me
up alive. We talked in my studio this morning for quite a
while. I feel like moving slowly through space this morning—
I feel gentle with myself. I'll check at the office to see if the
art supplies I ordered have come from New York yet. I want
to look at my painting *The Dream* and see if I want to cover
some of the turquoise (worked four hours on *The Dream* on

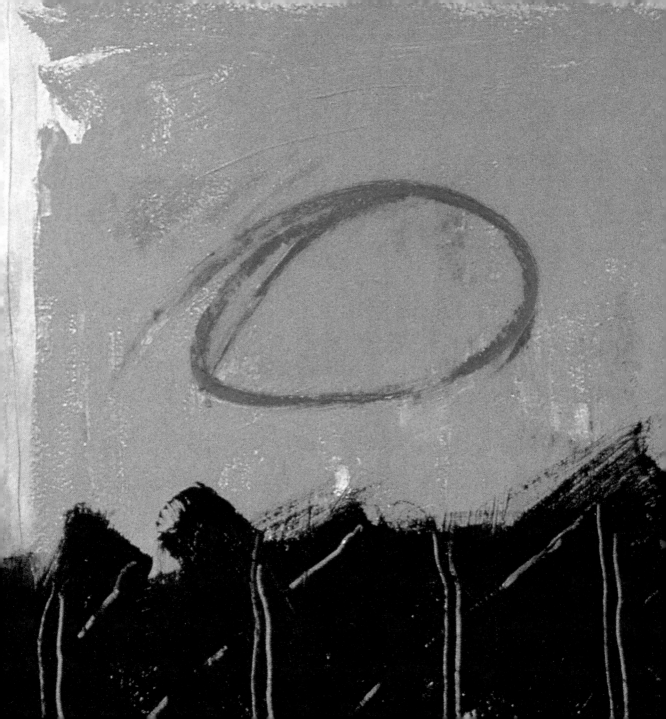

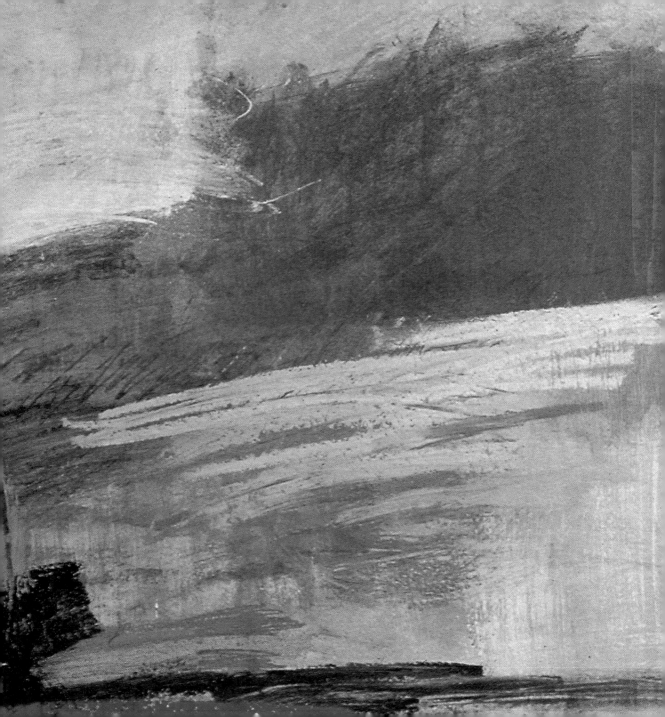

Friday—too much turquoise still). I did change *The Dream*—added black. There was just too much color in it, and I needed to make it as mysterious as the dream was. Hidden. Color hidden behind the black.

11:15 A.M.

Still haven't started painting this morning. Talked with Marilyn, the poet, and gave her the painting she inspired called *In the Face of Solitude,* and I gave Ann *Old Doors* as a gift—I love to give my work away to friends who I know will live with it and treasure it. I don't like holding on to work anyway—I'm grateful someone loves it and wants it. I got a letter from Jessica in Colorado—she sounds like her summer bus trip is great. I miss her. I laughed when she wrote that there is a lot of "schlepping" (of luggage), but she usually can "charm someone"

> I love to give my work away to friends who I know will live with it and treasure it. I don't like holding on to work anyway—I'm grateful someone loves it and wants it.

into helping her. Charm—her great gift—I write her back that it's a great tool and to use it wisely.

I'm going to work on a piece called *In the Face of Solitude II*. (I am running out of art supplies. The supplies I ordered from New York *still* have not arrived!) Good to spend the morning with such bright, sensitive people but always feel this "nudging" that I should be working. God, give me a break! I took down all the work from the walls that I have done here during the last two weeks, about fourteen works, which have covered every surface. I needed empty white walls again—did three drawings/paintings today, "smallish": (1) *In the Face of Solitude II*, (2) *Emotional Truth*, (3) *Summer's Pure Waters*. They felt like small poems and very satisfying and full of color.

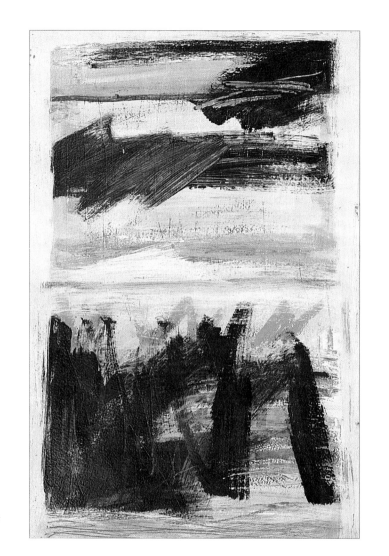

*In the Face of
Solitude*, acrylic
on paper,
22" x 16", 1992.

Following page:
detail from *In the
Face of Solitude*.

Went to the pay phone very early this morning and talked
with Lois—haven't talked with her in two weeks—and talked
with Susan in New York—she's leaving for Germany, Israel,
Turkey, and Greece. Good to talk to my friends. I am feeling a
little lonely, and a day here can feel like a year. Very anxious
and "hungry" last night—restless—trapped—no car, *dying* for
soft frozen yogurt. Shelly got me aggravated on the phone
yesterday. I guess this is inevitable with our being apart, but it
got me upset. I love him. I wish he'd just let me be. Hope my
supplies come today.

Break 10:30 A.M. Working on an oil on canvas called *Walking
with Turquoise Light*, dealing with the spiritual protection I feel
in my life. Turquoise light refers to the "Shechinah," and it's
the color of the light I saw, several years ago, after I was
accosted by a stranger, a man with a knife, in our home in
Georgetown. I will try to leave the painting alone and trust I

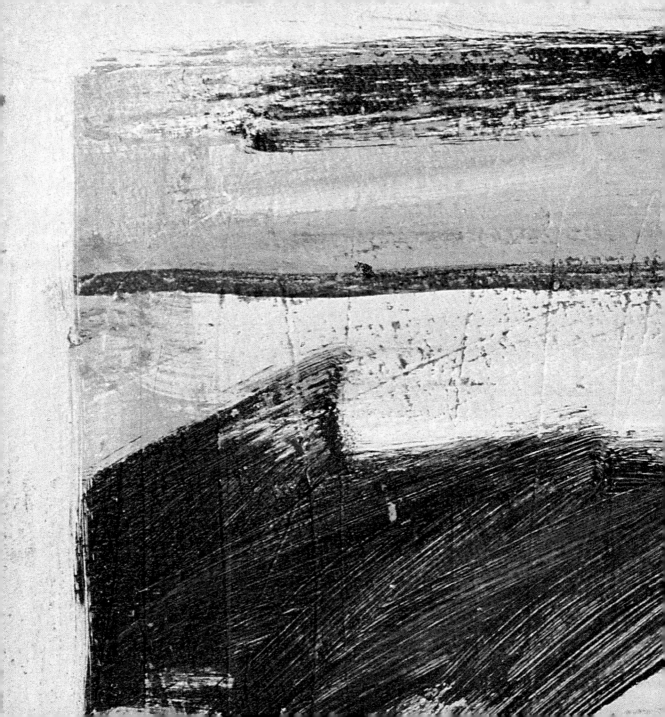

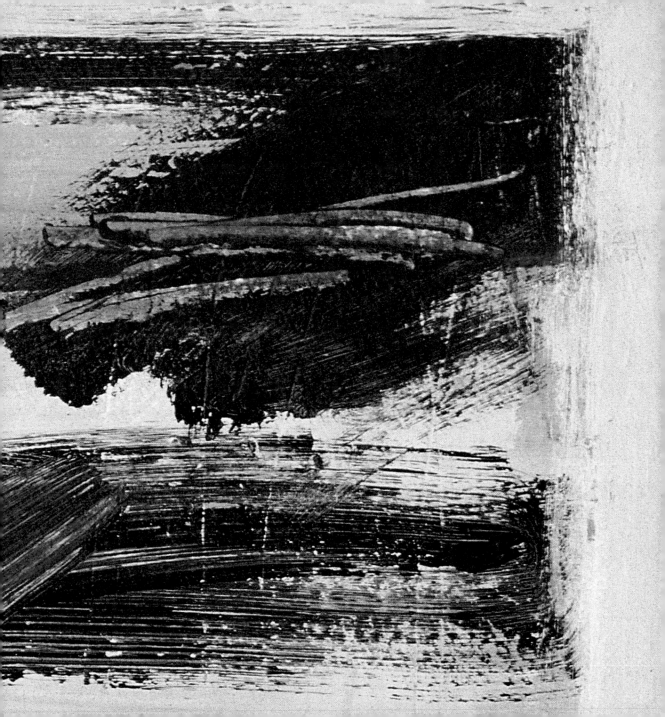

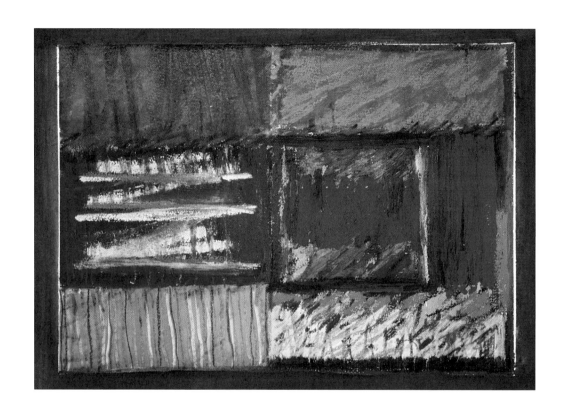

Summer's Pure Waters,
watercolor, oil pastel,
24" x 29", 1992.

Following page:
detail from
Summer's Pure Waters.

got down the emotion. I don't want to overwork it. There is no more emotion in me right now to spend on it anyhow. But who knows? My supplies are limited, and if I had a bucket of beautiful turquoise paint available, what might happen? The paint clearly has a life of its own and truly tells me "what next." It's my job to listen. I find it easier to listen here.

My supplies came—not exactly what I ordered: I asked for a large box of oil pastels, thinking maybe a box with fifty colors—but they sent me Holbein's box of 225 oil pastels in a multitude of colors for $491! Conflicted about keeping it—so expensive!—but just did a drawing with them called *Summer's Diamonds*. It'll be worth it as long as I use them, and they are just beautiful to work with. Smooth and true color.

Walking with Turquoise Light ended up being very dark. I'm getting a headache—the heat, the oil paint, turpentine fumes. I would kill for a soft frozen yogurt right now. No car. Too far

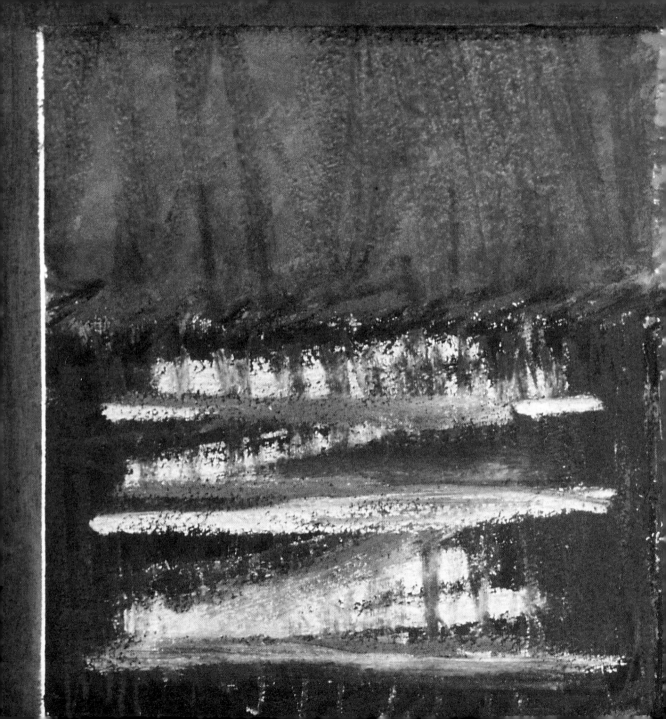

to walk. Maybe Ann will take me to the market later.
I need bottled water and something sweet. I am dying for
something sweet.

WEDNESDAY, JULY 22

I'm in my studio by 7:30 this morning—I bring my breakfast
here and eat quietly in the studio looking at *Walking with
Turquoise Light*, which I love and which feels most like me,
black and full of color at the same time. Last night was fasci-
nating—one of the poets invited a few of us into her writing
studio to hear her poetry. She was absolutely transporting in
the way she read—she is a *beautiful* writer and woman. (After
the reading Marilyn K. drove Joelle and me to the market—
hallelujah!—for water, and I found some good vanilla yogurt
for breakfast—so happy!) Jeanette, the poet, left me books in
my mailbox on "dreamwork" this morning, and I'll look at
them later today. I feel less lonely today. This "being only with

myself" to worry about is a first in my lifetime. I'm safe here, my needs are met, and I am free to just go deeper and deeper into myself—looking (digging for gold?) for what answers? For what new thing to say? (Bless this new fan Shelly bought me on the way home from Wintergreen on Sunday! It's quiet!) I'm so grateful I have a good studio set up in Washington. But I definitely will need to learn how to incorporate more of this quiet, which I find so constructive to being and feeling more creative.

MORE WORKS TO DATE:

In the Face of Solitude II

Emotional Truth (drawing)

Summer's Pure Waters (watercolor & oil pastel)

Walking with Turquoise Light (oil on canvas)

Summer's Diamonds (oil pastel)

Emotional Truth,
watercolor and pens,
26" x 40", 1992.

Following page: detail
from *Emotional Truth*.

9 A.M.

Reading *Working on Yourself Alone* by Dr. Mindell, given to me by one of the poets here, and came upon a paragraph, "The Alchemist's Gold"—incredible title after I had just written here earlier: "What am I looking for? Am I digging for gold?" He writes, "The Alchemist's gold is greater contact with experience of, and sometimes even insight into, her own and others' nature. This gold comes in the exact form she needs. The alchemist may get increased warmth, love and flexibility, increased sense of warriorship or toughness, freedom from symptoms, or simply an end to exhaustion." I could use all of the above!

2:30 P.M.

Finished *The Alchemist's Gold*. I worked straight through for five and a half hours, using every supply—oil pastels, chalks, watercolors, acrylics, oil sticks—I got totally lost and *loved* it! Definitely talks of the mystery of art/life. I'm outa here—will

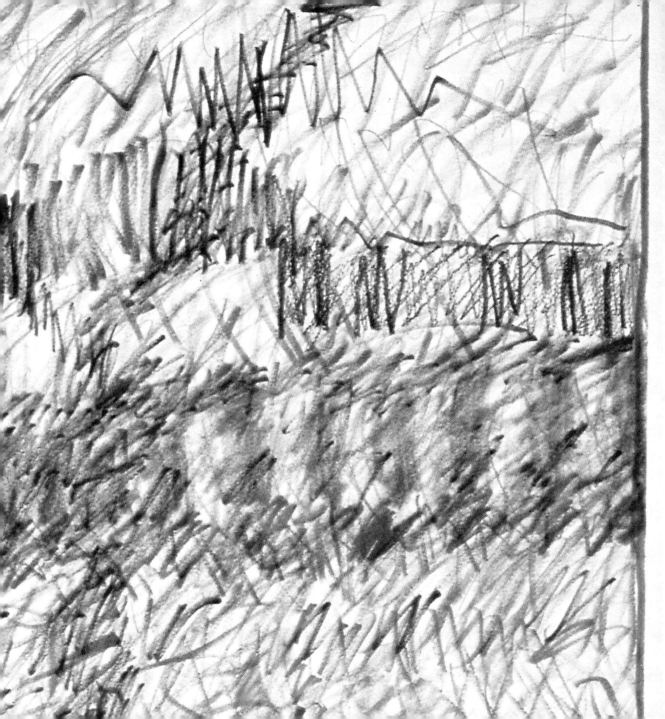

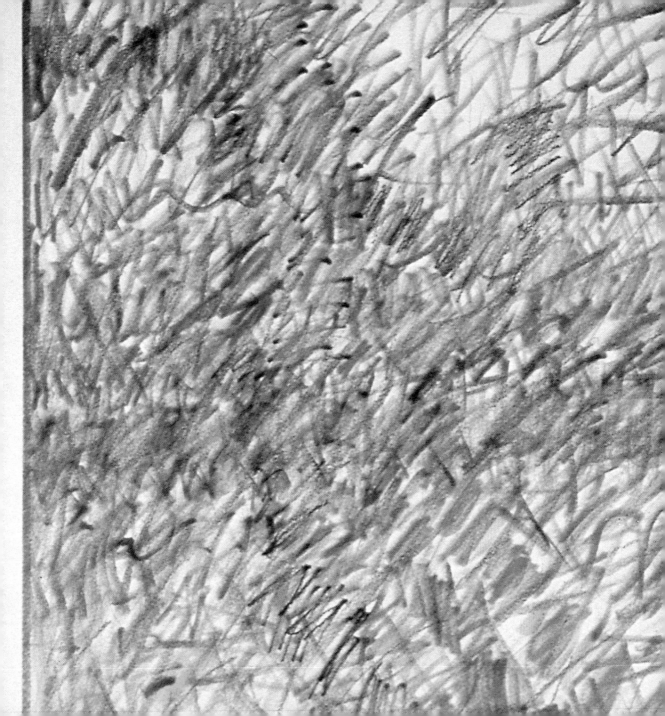

go walk-nap-bathe-read—I'm totally spent! And I rehung the walls with what I've done so far 'cause some writers want to come into the studio tomorrow. I'll have an "open studio."

THURSDAY, JULY 24

Most delicious morning—it was raining very hard. I went down for some breakfast and right up into bed again. Read *Lolita*—Nabokov's language is marvelous—and slept and watched the rain. Wrote a card to Carolyn and just felt a coziness I don't feel too often—a real gift. Stopped on my way to the studio to call Shel, and in my mailbox there was mail from Phyllis and Anne from home. Also in the mailbox was a book of poems that Marilyn K. had left for me to read. The poems are written by Tess Gallagher. I'm going to

I'm going to miss some very real things here that I have never known before—the untouchable quiet, the input from the other artists here, the nurturing and respect and total understanding of what I'm doing. . . . I am learning to trust what I need to do and am not pushing against myself.

miss some very real things here that I have never known before—the untouchable quiet, the input from the other artists here, the nurturing and respect and total understanding of what I'm doing. Don't feel in any hurry to get to work today. I think I totally exhausted myself yesterday doing *The Alchemist's Gold*. I am learning to trust what I need to do and am not pushing against myself.

STUDIO, 2:30 P.M.

I read Tess Gallagher's poems for one hour in absolute silence. And I cried when I finished reading, and while still crying, I put on Bach to do a black-and-white work on paper called *A Day with No Hurry*. I'm going for a walk. I'm drained. I didn't have any energy left for color today, only black and white.

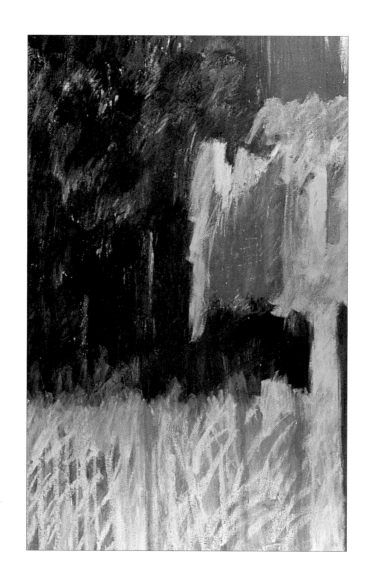

The Alchemist's Gold, acrylic, oil pastel, 60" x 40", 1992.

FRIDAY, JULY 25 / STUDIO, 8:30 A.M.

I had my open studio for my writer friends here—the response was terrific. One of the writers read her work to us while in my studio—her nonfiction was good, her fiction not so good. She lost everyone while she was reading the fiction, and I could tell they were getting lost into my paintings (as Marilyn Kallet tells it). Shelly is picking me up at 5:00—so I have only the day to work, rest, read, and wash my hair! I can't wait to see him. I feel reenergized after my cozy, unhurried day of rain and tears yesterday.

It is 9:45 A.M., and I am still not painting. Joelle came to the studio, and I gave her an oil pastel study I did—it made her happy. How could I not give it to her—I'd like to give one of the writers a small work, but I don't have another one, yet, that I'm ready to part with. It's not easy parting with some of these (I do miss the painting *Old Doors* that I gave Ann, for example!) but the thrill of knowing they'll live with and

Facing page:
detail from
The Alchemist's Gold.

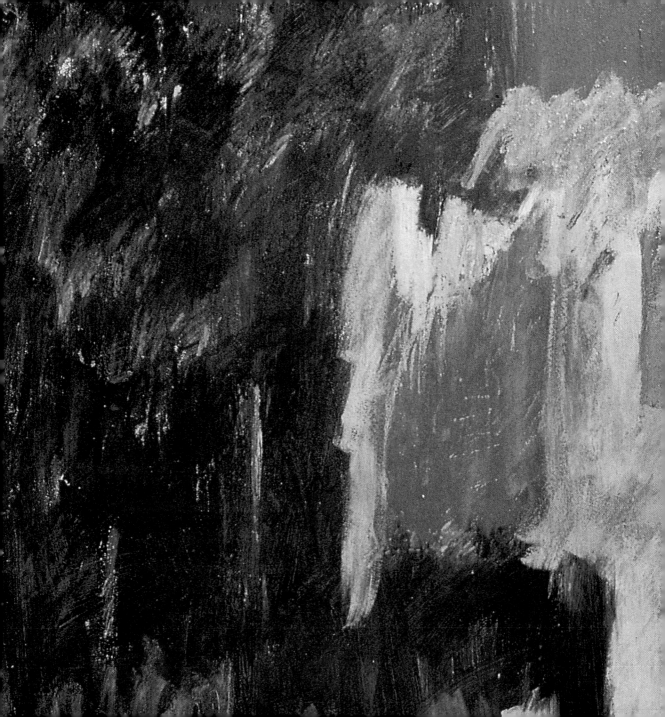

treasure the work means more—how else can I really give a part of myself? O.K. TO WORK.

It is almost noon. I can't fight this anymore—I feel sick. My head—my stomach—no energy. Truly no energy. I'm upset that I don't feel well because I just got new paints from Maccos in Bethesda (delivered in two days!) and would love it if I could work. I'm going to stay in bed—read and rest as long as I need to so I'm not such a wreck when Shelly comes at 5:00. It will be the first day here in three weeks that I will not have made a painting. It makes me anxious—but I'm too sick to fight it today. My body hurts.

4:45 P.M.

Rested all day, then in studio at 4:00 and in forty-five minutes, very focused, did an oil pastel/drawing called *Gray Friday*. Looks and feels just like the rain outside and the rain in my heart.

SUNDAY, JULY 27

Shelly picked me up Friday at 5 P.M. *Wonderful* to see him.
Went directly to Stony Creek Veranda Restaurant for dinner
and ate too much. Shel and I very close.

We shared the quietest, sweetest time together on Saturday
afternoon. I want to do a painting called *Quiet Abandon* about
it. We played tennis again this morning and ate our lunches
on the deck looking out at the mountains. Very special time.
He brought me back to VCCA by 2:15 and helped me take
down all the work done here to date, then took it home with
him—so it'll be easier loading up next weekend. This is the
last week of my fellowship. I look forward to being reunited
with my children—everyone home safely, please God, from
their journeys. I am starting to miss our summer family din-
ners out at the pool and in the garden.

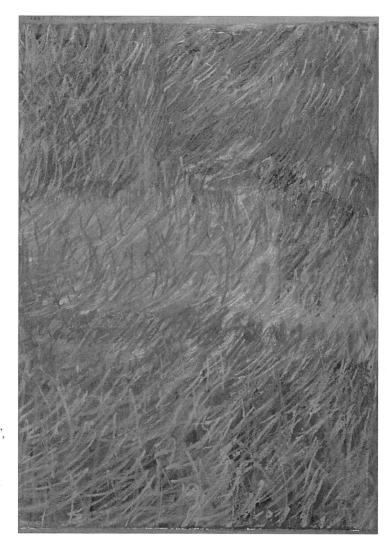

*Friday's Rain
(Gray Friday)*,
watercolor, oil
pastel, 40" x 28",
1992.

Following page:
detail from
*Friday's Rain
(Gray Friday)*.

Knowing that I will be reentering "real life" soon, I start feeling anxious and concerned about the "career" part of my work. I start feeling protective about the work done here. I'm going to be careful about where, to whom, and how much this *Touching Quiet* series is going to go for. It's good to be back here in my studio. I'll read the Sunday *New York Times* and rest a bit—it sounds like a storm is coming in. I'll try to get myself into a frame of mind to get into the painting once again. Round four. Just to paint. And try to erase concerns about money and ambition—at least for a while.

MONDAY, JULY 27 / 7:50 A.M.

Reading an interesting piece in the *New Yorker* by Dr. Oliver Sachs on an artist obsessed with his early childhood home in Italy, which he paints and talks about day and night (artist: Magnani, town: Pontito), and in the article James Joyce is mentioned with his obsession about Dublin. I wonder if all my

art really does come from a deep connection-pain-soulfulness of my early Hasidic childhood in New York—the music, the emotion, the devotion (that and my mother's favorite color, cobalt blue, which I use every time I paint). As a child I had a turquoise sweater set that I loved and can still feel today how absolutely beautiful I felt every time I put it on. And there is so much turquoise in my painting. And I've started wanting turquoise clothes (ever since Marilyn picked out that wonderful top for me at Samanda's). Marilyn Kallet has left, and I miss her. Maybe I'll call her in Knoxville later today.

I'm going to talk to Ann for a minute—then to work. I miss Shelly. But I love and worship this quiet. I am so grateful. All day long, as I am painting, I hear the gentle prayer in my head that I used to say as a child when first waking up—my daily childhood chant. Strange, I used to say this small morning prayer, "Modeh Ahni," every day as a young child. Haven't thought about it or said it in many, many years—and this morning it's all I can hear inside myself.

1 P.M.

Just finished *A Childhood Chant*, based on the "Modeh Ahni" prayer, all in oil pastel, oil stick, chalks, and black acrylic. I'm totally spent and happy. I write the prayer over and over and over in the painting before I actually start to work. . . . I also did a small oil pastel as a gift for one of the writers and worked on a small drawing about my weekend with Shelly called *Entwined*. Time for a break.

TUESDAY, JULY 28 / 8 A.M.

Talked with Carolyn yesterday. I love my firstborn daughter so. I wish her the strength to find her own good way. I can't believe she is twenty! Mothers and daughters! I talked with Ariane last night—she's home from her month in camp, and I was so homesick for her I wanted to pack my bags and just leave. Now that I know she's home I want to be home as well. My "baby" is now ten. Amazing to me, three daughters, ten, fifteen, and twenty . . .

Interesting discovery about my work yesterday: it appears that when I'm dealing with old feelings, that is when I use black—I bury the color I put into the painting to start with, and try to call forth the essence of what was. Current experiences and emotions are done in full color—little or no black. Nothing to "bury." It's in the here and now. The here and now is quite nice.

Interesting discovery about my work yesterday: it appears that when I'm dealing with old feelings, that is when I use black—I bury the color, I put into the painting to start with, and try to call forth the essence of what was. Current experiences and emotions are done in full color—little or no black. Nothing to "bury." It's in the here and now.

I heard a writer here read her short story on rituals last night. Wonderful. Then at 8:30 walked to another writer's studio, in the pouring rain, to hear her read her screenplay that she's been working on. She's a great reader. I love this reality of everyone around me involved in creative work. And the desire to share it . . .

When I get home I will aim to continue working three mornings in my studio, write in this journal, and rest. One day a week I'll be teaching—so it should be a good balance. To work.

There is a coolness today, after last night's storm, that is such a relief from the terrible heat. Such wonderful coolness—breezes.

10 A.M.

Just finished an oil stick–and–oil pastel on paper called *With Abandon*—figurative and expressionistic—of my time with

Shelly last weekend in Wintergreen.

When I get home I will aim to continue working three mornings in my studio, write in this journal, and rest. One day a week I'll be teaching—so it should be a good balance.

3 P.M.

Worked all day. Did a total of three drawings—same size (40"x 26") as *With Abandon*. Lost complete track of time and got lost reliving what

Childhood Chant,
watercolor, oil pastel,
40" x 60", 1992.

Following page:
detail from
Childhood Chant.

Shelly and I shared last weekend. I need a rest. I'm spent. I'll call the first drawing *Quiet Abandon*.

WEDNESDAY, JULY 29 / 7:45 A.M.

I didn't go into the dining room for breakfast this morning but ate alone in my studio (two cartons of nonfat yogurt, all-bran and raisins). I am definitely starting to "separate" from here. I am really getting very ready to go back home—to the family I love and share life with.

I need to work on one of the *With Abandon* drawings—hope I can save it, not destroy it—I did put so much of myself into it. Yet I don't want to worry about "saving it"—I should just let the work have more of a life of its own.

Interesting discussion at the table about how most artists need quiet—none turn on the radio or TV the minute they walk into a room as most people do. Is it that there is so much more inside them already? Or that the quiet is what they need in order for the work to sprout? I'm getting very excited and thrilled that I have almost completed this one-month fellowship. *I did it!* I worked—I read—I rested—I walked—I DID IT! To work.

Interesting discussion at the table about how most artists need quiet—none turn on the radio or TV the minute they walk into a room as most people do. Is it that there is so much more inside them already? Or that the quiet is what they need in order for the work to sprout?

1 P.M.

Unbearably homesick this morning—I figured this would happen once I knew Ariane was home—I miss her! Also felt very, very dizzy—faint this morning. Ann said it must be low blood pressure. It might be the heat. Drank some caffeine—

feeling better. Called Shel about wanting to come home early, but I think I'll just proceed as planned. I'll talk to him again later. There really is a sense that I cannot be away from my "real life" another minute. I must really be ready for home.

Working on a painting, very geometric, using all the supplies I worked with all summer—watercolor, oil pastel, oil stick, and chalks—my last big (60"x 40") painting here, called *Goodbye to a Time*. Very colorful and joyful piece.

Have some reading to finish while still here—so will do that and then clean up.

Goodbye to a Time,
mixed media,
60" x 40", 1992.

Following page:
detail from
Goodbye to a Time.

WORKS TO DATE:

The Alchemist's Gold (mixed media)

A Day with No Hurry (black & white watercolor and oil pastel)

Gray Friday (oil pastel drawing)

A Childhood Chant (mixed media)

Entwined (small drawing)

With Abandon I (oil pastel drawing)

Quiet Abandon (oil pastel drawing)

Memory of a Time

Goodbye to a Time (mixed media)

Summer's Jazz I (small oil pastel)

Summer's Jazz II (small oil pastel)

The Queen of Kindness

THURSDAY, JULY 30 / 8 A.M.

Tomorrow is my last day here. I woke up at 5:15 this morning with incredible excitement, a sense of accomplishment, survival, new beginnings. Ann and I had a wonderful talk in my room last night about art and life,

I woke up excited that I go home tomorrow and that I had this month—it cannot be taken away—I had it, I did it, I worked as honestly and as hard as I could. I used my time well.

and this morning we took a brisk two-mile walk. She is a spiritual, lovely woman who has taught me to respect my quiet and recognize how much I need it to live more fully and peacefully with myself.

I woke up excited that I go home tomorrow and that I had this month—it cannot be taken away—I had it, I did it, I worked as honestly and as hard as I could. I used my time well. I will work on finishing *Goodbye to a Time*—then at 12:00 some of us are planning to go to Samanda's for lunch,

shop, and go for a ride in the Blue Ridge Mountains near here. Would like to see these grand green mountains before I return home.

Tomorrow I pack up. (Cora, the cook's husband, will paint this once white studio white again on Saturday—for the new fellow. I'm so glad I don't have to!) I finished Nabokov last night. Fascinating use of language and storytelling. Today and tomorrow would like to spend time with W. C. Williams poetry and Wallace Stevens poetry—something I had hoped to do during this stay. To work.

> I would like to give thanks, here and now, for this month in which I found the strength to do all this work that clearly was in me, longing to get out; for having the time, the energy, the desire, the inspiration, and the freedom in which to do it. A month from heaven.

FRIDAY, JULY 30 / 8 A.M.

Never did get to read the poetry yesterday—finished *Goodbye to a Time* listening to the Modern Jazz Quartet's *The Last Concert*. Very "up" painting. Had a fun outing yesterday to see the Natural Bridge in Virginia and the Blue Ridge Mountains. I'm overwhelmed by a deep sense of wonder. I don't feel I need to do anything with it—I don't need to paint it, make anything else out of it—just be happy for the experience of it.

Well, today is my last morning here. I am ready to go. At dinner last night Joelle said to me, "Mindy, you are the queen of kindness"—and that is when I instantly felt a painting needing to happen. So before I start to pack up today, I'd like to do this last painting or it'll bother me all weekend.

This has been a very "positively reinforcing" time. I have learned that I need to continue to work on being more in control of my generally exhausting emotional life—by just resting more and not taking on so much. I definitely do too much at home. No wonder I get totally depleted. I always want to do so much—but one day, you do wake up and say, "I am only one person."

I would like to give thanks, here and now, for this month in which I found the strength to do all this work that clearly was in me, longing to get out; for having the time, the energy, the desire, the inspiration, and the freedom in which to do it. A month from heaven. And thank you, God, that everyone I love and hold dear has stayed well.

I talked to my parents, who returned from their summer travels yesterday—they sound wonderful. I'm so happy when they sound good. To work, then to pack up.

10 A.M.

I just finished *The Queen of Kindness*; it takes on the feel of Lenore Tawney's tapestries, which I was looking at in a book of her work last night—I love the textural feel of it—I did it on those wonderful Twin Rocker handmade paper squares. There is nothing like the feel and texture of handmade paper.

I'm home! And write this in my studio at home. Thrilled to be home! The house looks so big, so clean, so beautiful. I LOVE my studio! Good to be home . . . As soon as I enter the studio here I enter a quiet world. It's been here at home all along.

MONDAY, AUGUST 3

I'm home! And write this in my studio at home. Thrilled to be home! The house looks so big, so clean, so beautiful.

I LOVE my studio! Good to be home. Will try to sell some of my older work this upcoming month in order to rebuild my savings account, which got entirely depleted with this past month's art expenses. As soon as I enter the studio here I enter a quiet world. It's been here at home all along.

Mindy
Weisel, 1992.

AFTERWORD

It has become quite clear to me, after rereading this journal recently,
that I was able to get as much painting done as I did at the
VCCA because that is all I had to do. I didn't have to teach,
shop, cook, drive, take care of a family or worry about any-
thing except making my work. This is, obviously, not real life.
That's why they call these places "artists' *retreats*." The idea is
to incorporate a bit of a retreat into our daily lives.

Many years ago, in a conversation with the feminist Gloria
Steinem in which we were discussing the "right" to have time
for oneself, I declared that "freedom comes only after one
handles one's responsibilities." Ms. Steinem rebutted, "No, free-
dom comes from accepting your choices." I suspect we were
both saying the same thing.

I have accepted the choices I have made in life but do still feel my time is my own only after handling my family responsibilities. I'm not saying this choice has been easy. I often have wondered at the sanity of believing I could be a mother, a wife, and an artist.

I have accepted the choices I have made in life but do still feel my time is my own only after handling my family responsibilities. I'm not saying this choice has been easy. I often have wondered at the sanity of believing I could be a mother, a wife, and an artist. Often the whole situation was very frustrating. I did not, for example, have the luxury of doing my work only when "inspired." Most often the inspiration had to wait— often having to put creative needs aside owing to family demands. The hardest part was to learn to sit with the feelings stirring inside me, longing to be expressed in my work, my paintings. But these feelings had to wait their turn. When I finally did get to my studio, my place of quiet, there would be a tremendous outpouring of what I'd seen, felt, experienced since the last time I was there.

The irony is that this often demanding and "traditional" life I have chosen, grounded by responsibilities toward children, husband, family, friends, and community, has served my creative life well. It has encouraged and forced me to be focused and disciplined with my time and energy. There really wasn't time to waste.

If I get too far away from time with myself—time to contemplate, reflect, make some "sense" out of life—I get too far away from the authentic center of who I am. If I do not allow myself the necessary daily quiet, I feel more frantic, and it feels like I am moving from crisis to crisis.

I have noticed through the years that when I am not respecting my need for quiet and solitude, I am definitely more anxious, short-tempered, or, as my mother used to say, "nervous." If I get too far away from time with myself—time to contemplate, reflect, make some "sense" out of life—I get too far away from the authentic center of who I am. If I do not allow myself the necessary daily quiet, I feel more frantic, and it feels like I am moving from crisis to crisis. I think of quiet and

solitude now as "money in the bank": the more quiet time I can incorporate in my day, the more reserve I have for the natural stresses, demands, and obligations of daily living.

Most people do, I feel, make the mistake of waiting to pursue their own interests or to take time for themselves till "later" . . . till children are grown or they don't have to work long, hard hours, etc. We can all find an excuse for not spending time with ourselves. My doctor, Berl Mendel, taught me, wisely, not to let life give me "excuses" to keep me from my work. Work that is created from the heart; the work that adds meaning to life; the work that, in the process of the creative struggle, creates order out of internal chaos; the work that expresses what we feel deeply—thoughts and feelings authentically our own. It is this life's work that allows for a deeper meaning to our everyday experience.

I find an anchoring of my self when I paint. There is no question that it is not and has not been easy finding the time to be alone with myself to do what I love.

Many people feel this in the form of prayer, some in dance, others in music. It's different for everyone.

I find an anchoring of my self when I paint. There is no question that it is not and has not been easy finding the time to be alone with myself to do what I love. There were times when my daughters were younger that by the time I'd get to the studio, I'd literally have to lie down on the hard floor and just sleep. Totally exhausted! And I'd be upset, foolishly, that I had "wasted" an hour of my already limited time to sleep! But there was no choice. I was totally spent from the other demands of my life, and I needed to rest before I could get to the work of my heart . . . before I could even think of starting to paint.

Mindy and Shel
Weisel, 1992.

We lose the center of ourselves somewhere along the way if we are not spending even a small measure of time alone with ourselves. We need some time alone to listen to what we are thinking and feeling. We need time to sort things out, to gain insight into what is important. When we "retreat" it is an opportunity to "recharge." Sometimes all we need is an hour, quiet in our room, and then we can continue once again.

The absence of silence, inflicted on us by the modern, high-tech world we live in, robs us of much necessary time for the contemplation and reflection in which our inner selves can strengthen and grow. We must guard our quiet time dearly. And daily.

Listen to the quiet. Make that an "activity" if you must. Harmony will be the reward. As well as peace of mind.

Cherries in a Crystal Bowl
by Sauci S. Churchill

I know
A potter
Who makes
Covered jars
So he may
Look inside
And find the secret

There are
New cracks
In the crystal bowl
But darkness
Has been pierced
Like the shell
Of an egg
And light has found
New ways to enter

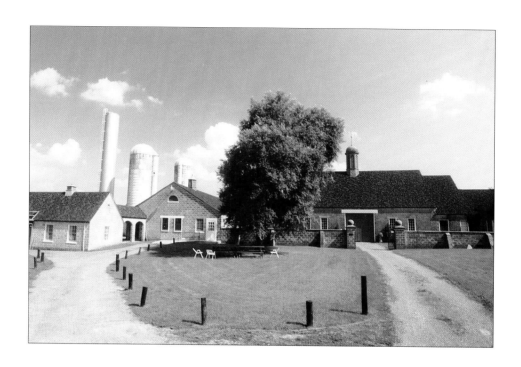

Virginia Center for the
Creative Arts retreat.

Virginia Center for the Creative Arts (VCCA)

The Virginia Center for the Creative Arts is one of the nation's foremost working retreats for writers, visual artists, composers, performance artists, filmmakers, and artists whose work crosses disciplines. Since 1971, the program has catered to mature artists of noteworthy achievement and promising younger and midcareer artists. Many are among America's leading artists—winners of the Pulitzer Prize; Rome Prize; National Book Award; and fellowships from the National Endowment for the Arts, the Guggenheim Foundation, and the MacArthur Foundation. VCCA provides residential fellowships in a rural setting where artists may concentrate on their creative work, free from the distractions and responsibilities of day-to-day life.

From the *Touching Quiet Series* by Mindy Weisel
(listed in order of appearance)

Looking for Quiet, 38"x 37½", watercolor collage, 1992
(private collection), p. 10

Of Snakes and Partings, 40"x 60", watercolor, acrylic and pastel,
1992 (private collection), p. 22

Touching Quiet, 34"x 26", watercolor and oil pastel collage,
1992 (collection of Wendelin White and Paul Feinberg), p. 32

Of Country Fields and Torn Skies, 60"x 40", watercolor, oil, and
pastel on paper, 1992 (collection of Margie and Stuart Seides),
p. 38

The Fields, 50"x 30", oil pastel and watercolor, 1992
(collection of Victoria Perkins and Roger Hess), p. 44

A Storm of Solitude, 40"x 60", watercolor, oil stick, 1992
(private collection), p. 50

The Lake, 34"x 42", watercolor and oil pastel, 1992
(collection of Debbie and Jonathan Rutenberg), p. 56

The Dream, 34"x 47", acrylic and oil pastel, 1992
(private collection), p. 62

In the Face of Solitude, 22"x 16", acrylic, 1992
(private collection), p. 68

Summer's Pure Waters, 24"x 29", watercolor and oil pastel, 1992
(private collection), p. 72

Emotional Truth, 26"x 40", watercolor and pen on paper, 1992
(private collection), p. 78

The Alchemist's Gold, 60"x 40", acrylic and oil pastel on paper,
1992 (private collection), p. 84

Friday's Rain (Gray Friday), 40"x 28", watercolor and oil pastel,
1992 (collection of George and Cheryl Crowley), p. 90

Childhood Chant, 40"x 60", watercolor and oil pastel, 1992
(private collection), p. 98

Goodbye to a Time, 60"x 40", mixed media on paper, 1992
(collection of Sharon and Leo Rozmaryn), p. 104

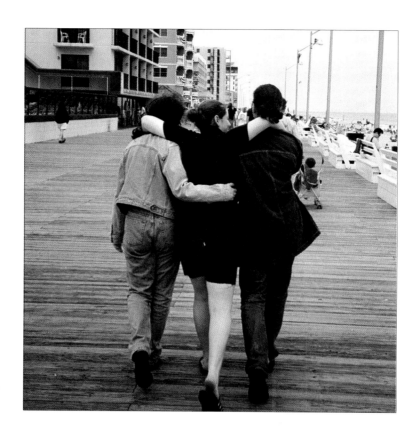

Mindy Weisel's daughters
on the boardwalk, 1998.